The End of The Rainbow represents not only my own experience, but also stories told by others in a desperate moment or during a glorious display of empathic abilities taught by the masters of hunger and dependencies. It is also a reflection of my view on spiritual and /or emotional human polarity and some of the subsequent behaviors that transcend age, gender and social status...not to mention "lifestyle". Human polarity, that is in itself, part of the essence of our nature.

Most of us expend great effort in trying to find the treasure, the Holy Grail, the secret to happiness...
And yet spiritual laziness seems to be one of the greatest achievements of our personal and collective egos.

Old news? Claro!... but who among us can silently claim the trophy of achieving true emotional balance? That balance of extremes which escapes our grasp, like a wonderful dream to be continued after awakening but instead, the day becomes a series of nightmarish events of our own creation?

How many of us can let go of the wrong turns taken and embrace fully, with no fears or doubts, a bright new moment that could lead us into a happy new future? A moment so evident that, more often than not, we miss or dismiss?

The End of The Rainbow, like the end of any journey, is also the beginning of another, with all the questions yet to be asked of all the knowledge yet to be acquired.

It is simple urban poetry, colloquial talk fused with images. Images that by themselves tell one story or two.

Images and words that echo each other like mirrors from our past that could reflect our future. So the luxury of been oblivious to the concept " A conscious present builds a brighter destiny" is not an option. We are not to forget that "Destiny" is only one of the outcomes of the precipitation of infinite possibilities that "is" our "Now" So smile and be at peace...The present is all we have!

 love to all
 Mario

The Fallen

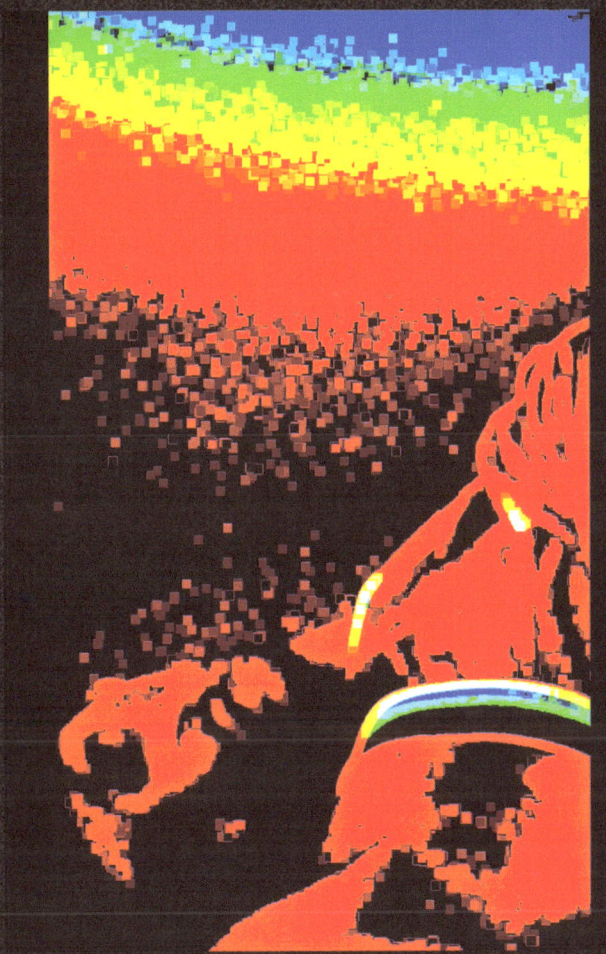

Only alone the fallen rise. Only when their time seems to be right
no matters how loud and desperate we scream...
I'll help you! Use my hand! I am here!
none of that matters they are paralyzed by chaos, starvation and fear
only their souls, their essence ...their God from within
can save them and bring peace with the whisper of a quiet and gentle breeze.

The Lost Cause

Rushing into a humanitarian crusade, I decided to save the world
but at the end of my journey my shiny sword was gone
I saw only my hand crying out for help... I was alone
it turned out that my crusade was only a delusion
a mirage played by my ego to overturn my soul
my awareness compensated for the lost cause though
while left empty handed and weaker than I was before.

The Blind

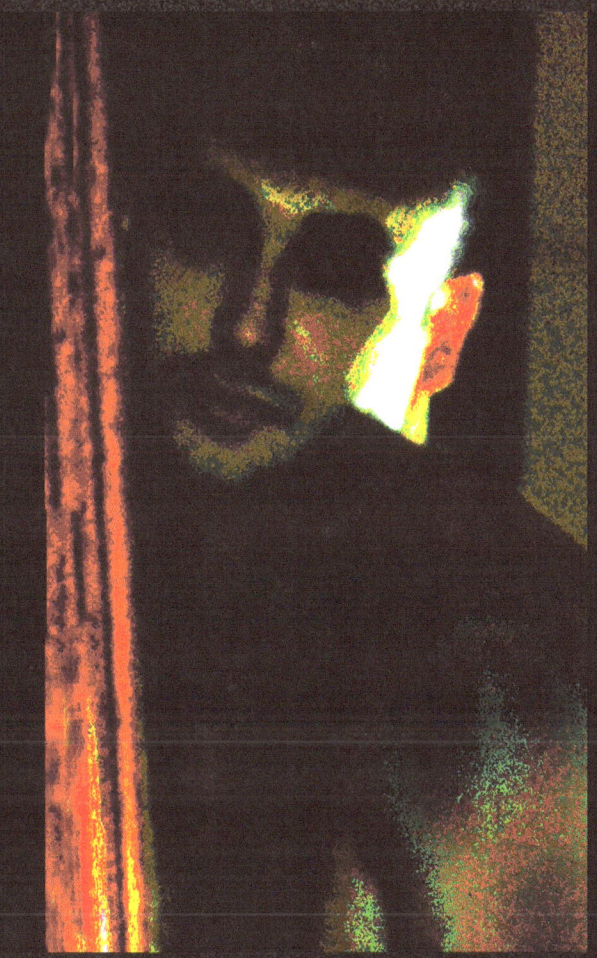

"Careful when chasing the rainbow blindly"
that was the voice from inside
even with eyes wide open ,the colors were not so bright
fiddle with that crystal! Get it close to the light!
but it burns!... said the blind
but he wasn't just blind
he was also deaf to the advise
from the little voice from inside.

The G

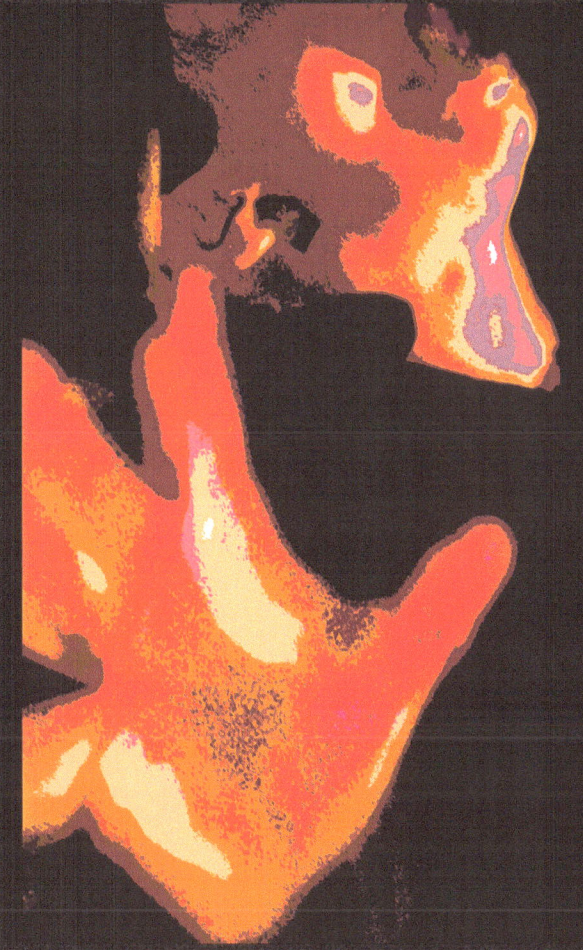

New style of friendship between humans and a new generation G.
bringing new meaning to the sweet and caring words
"it's OK for humans too!... I care for you so."
Even though the bottom of the Styrofoam cup was gone
the party went on and on and on.
So drink to the acid taste of sweat!
go into the depths of tomorrow
celebrating the scars of your wars
and grieving over the pain of your sorrows.

The Dog Food

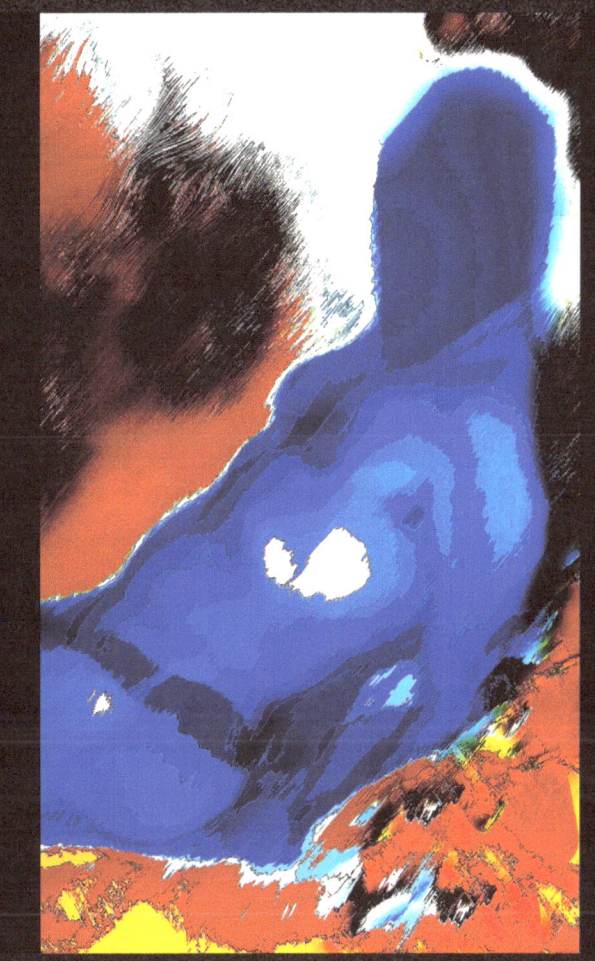

Lust...

The Search

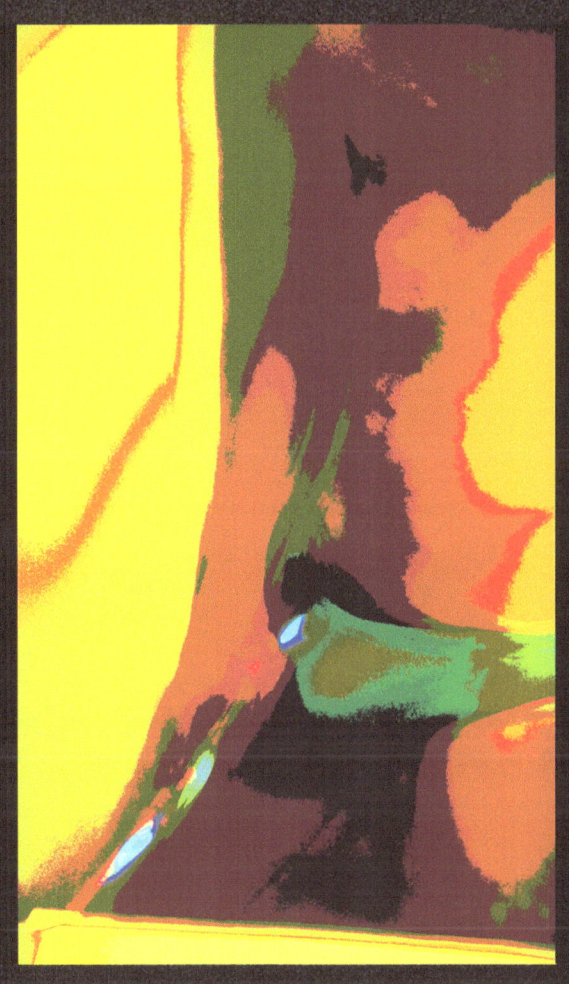

Self...

The Wise

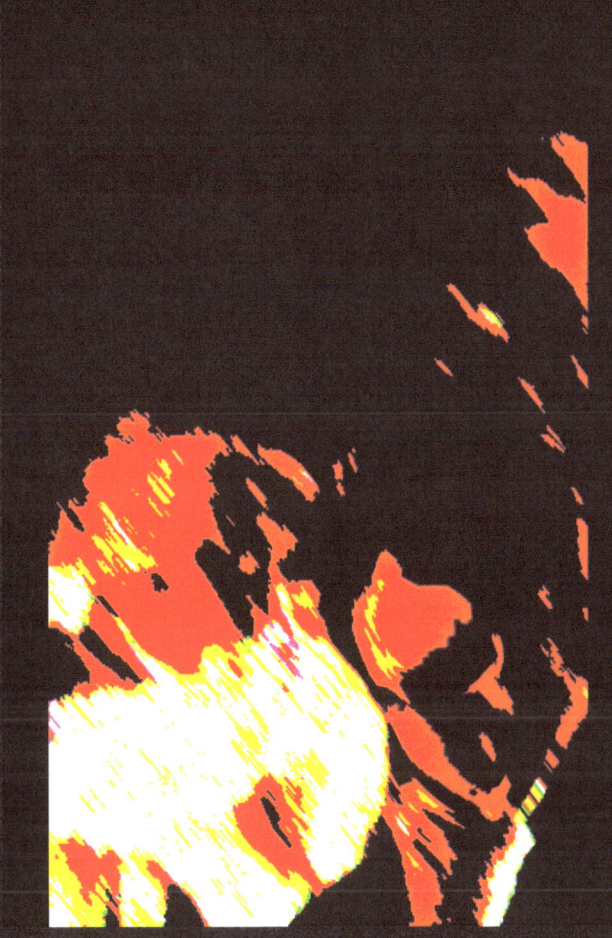

The same old souls
teaching the same old lessons, using the same old words
Is this time ...your time?
Someone, somebody...please pay attention!

The Queen

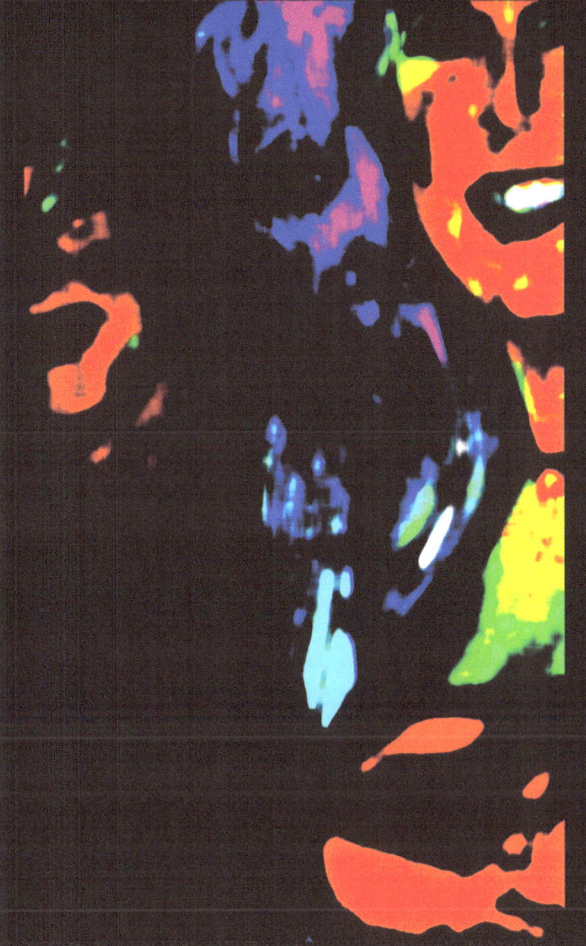

Dragging her layers of colors while competing the night out
that is the plan! winning the goal!
she's got to be festive. No doubt, she's got to be strong
it took time to get ready. well ...now it's time to go on
with the courage to play her role in just a fraction of the time
there is no room for failure. There is no time to cry
Calm down she tells herself...after all she's a pro
it's not about her beauty, certainly not about being tall
remain cool, calm and collected. It is time to show off
how fabulous and top drawer are the actual colors of his soul.

The Prisoner

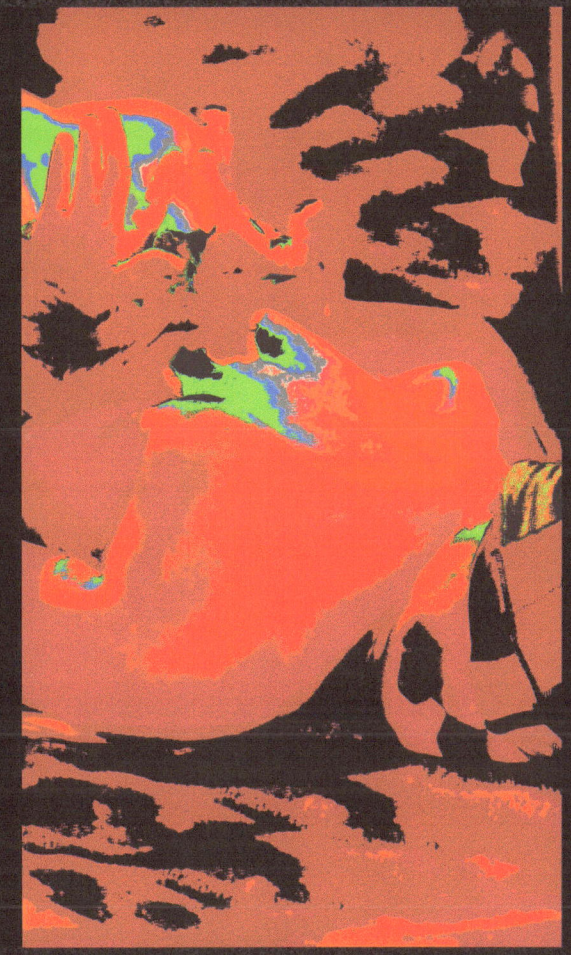

Rainbows distorted under the magic spells
of man made crystals foundation of a dark fairy-tale
our minds enchanted our bodies enslaved
trapped by hungry demons concealed behind a genteel face
we embrace the lie with insatiable lust and greed
blinded by the colors and cursed by the need
the currency changes and we gladly agree
to renounce our freedom
to entertain the hunger and push back the need.

The Soldier

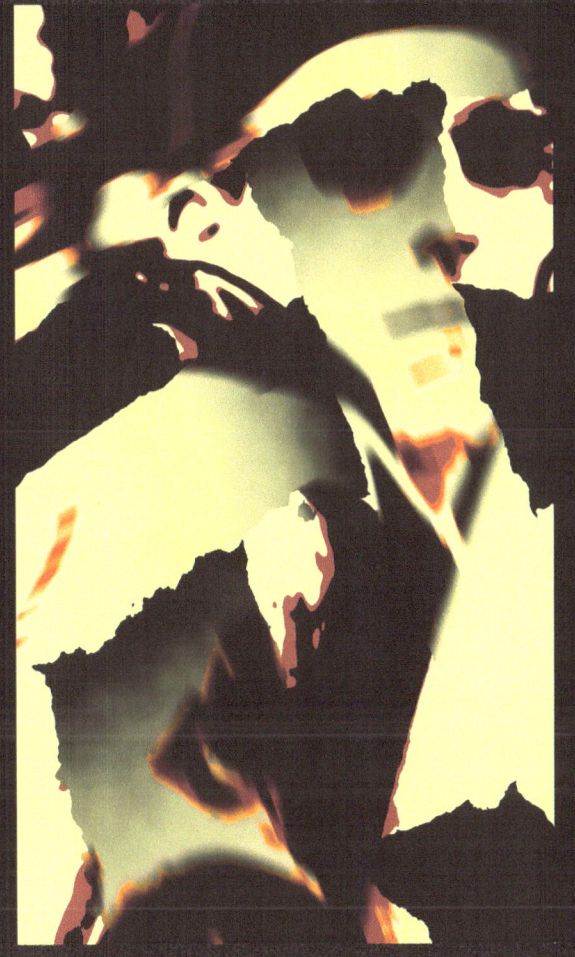

Going to war leaving behind family, love and life
to chase other people's rainbows and create for other people paths
and all this without brand names or disco lights
everything turns into "so last season"
while the count still remains increasingly high
there is an additional worry though...not just to stay alive
don't ask and don't tell... it'll be all right!
right?

The Roman

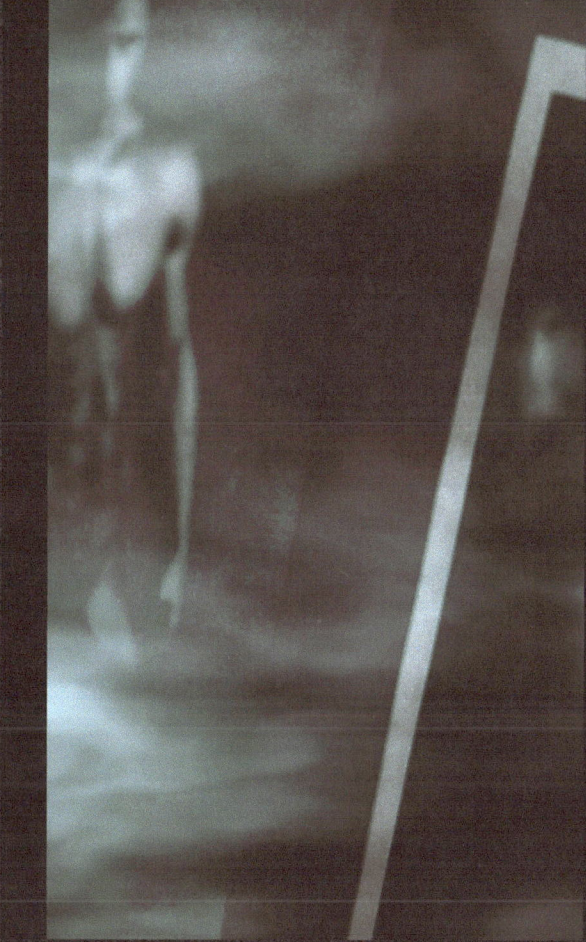

ACT I

The steam creates an atmosphere of timeless youth, that deceives our senses getting us in tune.
The stage is set. The empire conquers lands any and everywhere.
Every door could be a gate to satisfaction. Every door is almost a certain gate to interaction.

ACT II

There is a sudden present roughness on the walls and a voice rising from below flickering over the music from outer space
one07 one02...two58 and two22 Time is up you fools! Pagan deities are gone, why bother to renew?

ACT III

The first light takes us back to the reality of self-imposed social equality
prompting us to wear our theatrical mask of arrogance and great magnitude
while having on our wrinkled robe of adjustable and urbane taught virtue.

The Shadow People

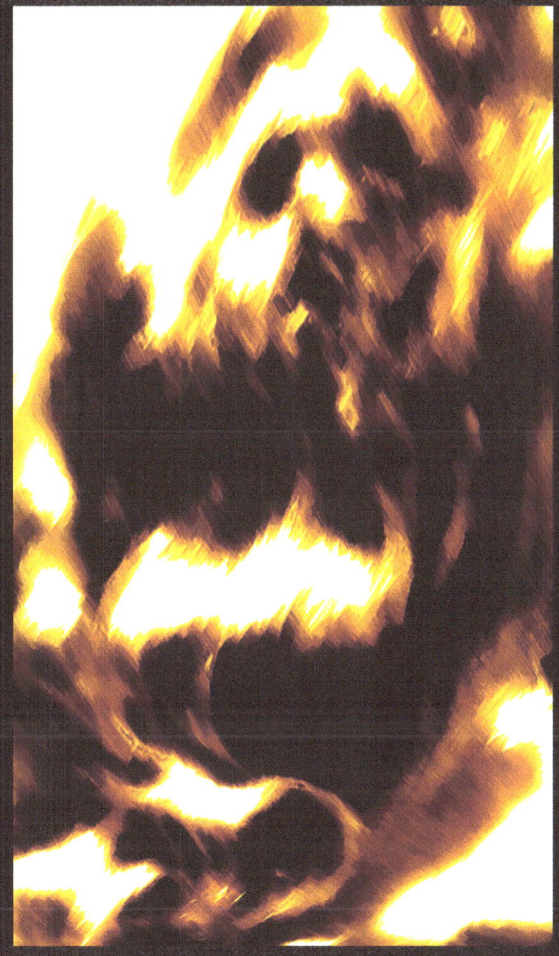

They seem to be real at the frontier of your sight
following, hounding...just one step behind
the only enemy they fear is the energy of your soul
powerful without limitations, radiant with God's grace and love
Oh...your love for life, that is your weapon
and the presence within you, that is your force
you are born with all you need to get rid of them all
Blessed elegance. Unpolluted light.
Celebrate...No more shadow people! Celebrate...No more shadow life!

The Healing Waters

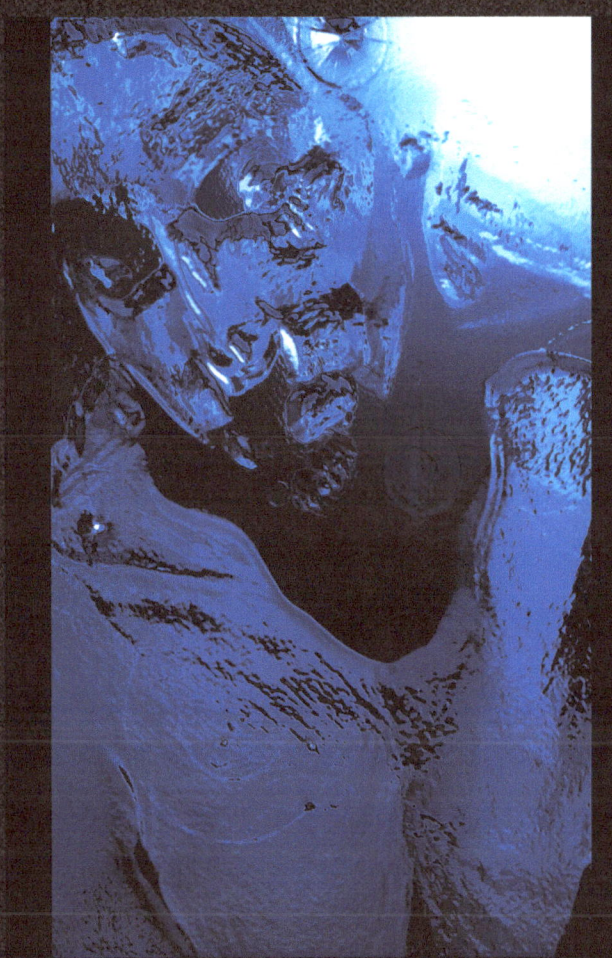

From the waters of my own tears...
I was re-born.

The Living Mind

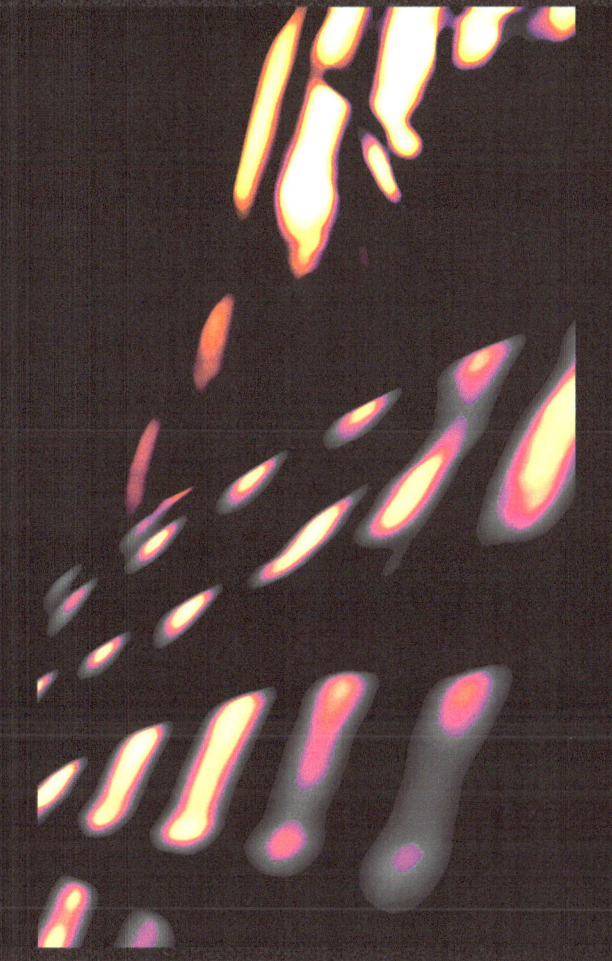

Resting calm and serene...in God we are at home.

The New Direction

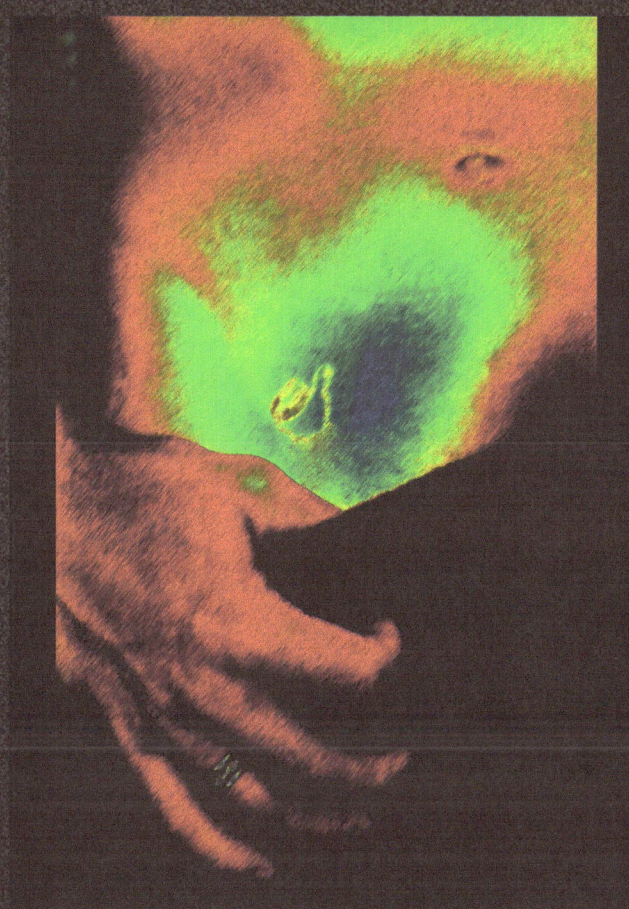

That of a child...

The Future

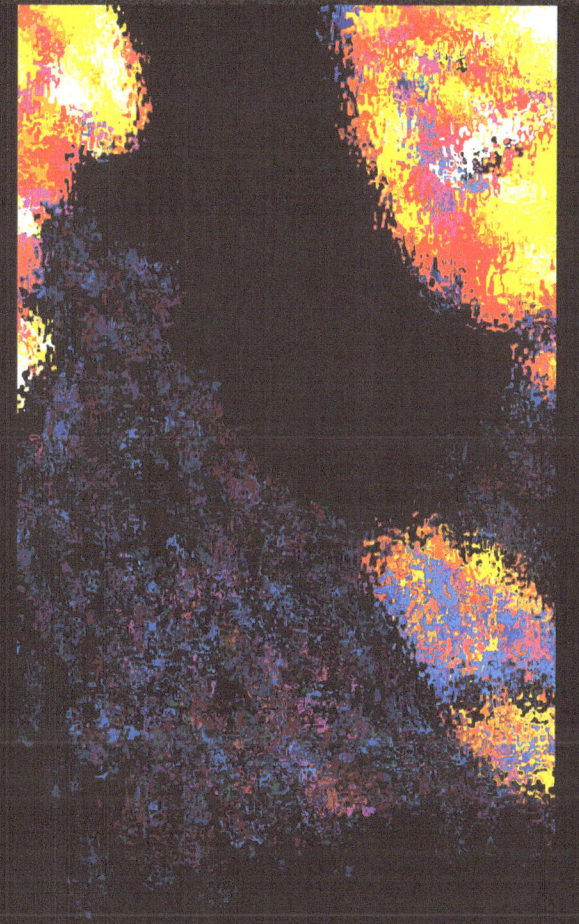

Unconditional love for all...

Mario Gonzalez D. was born in the South American city of Caracas, having assimilated decades ago into Houston's diverse cultural stew. Mario was instrumental in developing his family-owned Marketing Research firm, as well as Marketing Director for an international publishing company. Some of his most recent work can be seen at www.mariogonzalezd.com.

While comfortable mingling in the world of business, Mario also possesses an abstract creative side that allows his considerable talent for Photography and Design to shine through.

Although a rabid organizer, Mario also performs well when chaos abouds. A Romantic, A Dreamer and Father-Figure, with the heart and curiosity of a child. What he calls confusion, his friends quickly recognize as intelligence, they also lament its trappings... Mario's persistence to run the show! At times joyous and intense, other times calm but rarely quiet.

Above all, Mario enjoys a passion for life that is palpable. Not surprisingly, at ease with royalty and yet above no man, Mario is best described as a contradiction...right down to his salt and pepper mane!

<p style="text-align:right">A Friend</p>

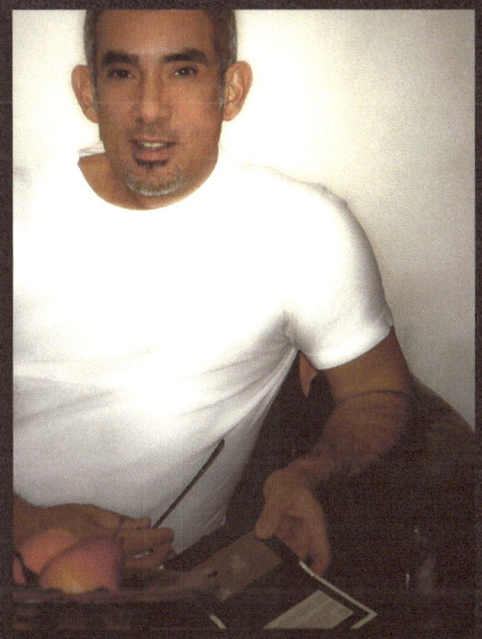

Mario Gonzalez D.

www.ingramcontent.com/pod-product-compliance
Lightning Source LLC
Chambersburg PA
CBHW051111180526
45172CB00002B/860